My name is Rufus.
I am a photographer.
[A dog's true story]

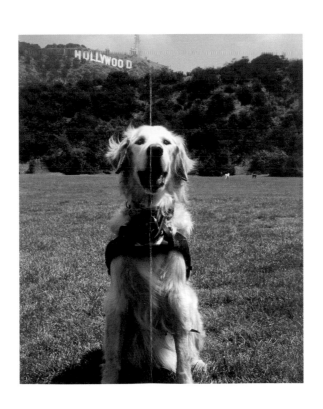

Photography by
Rufus Kanemoto [Golden Retriever]
Reiji Kanemoto [Human]

Text by
Bert Tanimoto

Printed in Hong Kong

10 9 8 7 6 5 4 3 2 1

First published in 2004 by
StudioTanimoto, Inc.
1455 Crenshaw Blvd., Suite 250
Torrance, CA 90501
www.studiotanimoto.com

A CIP record for this book is available
from the Library of Congress.
ISBN: 0-9746448-8-9

contents

rufus comes home

Rufus first came to my Los Angeles home in February of 1998. He was a beautiful Golden Retriever, perhaps 8 to 10 years old at the time. I first met Rufus at a friend's dog care center, where he had been staying for over 7 months, abandoned and neglected by his former caretakers.

I remember how lonely he looked; he had lived with some college students before, but as each of them graduated and went on, there wasn't anyone left to care for him anymore. I remember wishing I could do something to help him, but I just didn't have the confidence that I could take on that kind of responsibility. I visited Rufus several times after that day, and a month later, made the decision to bring him home.

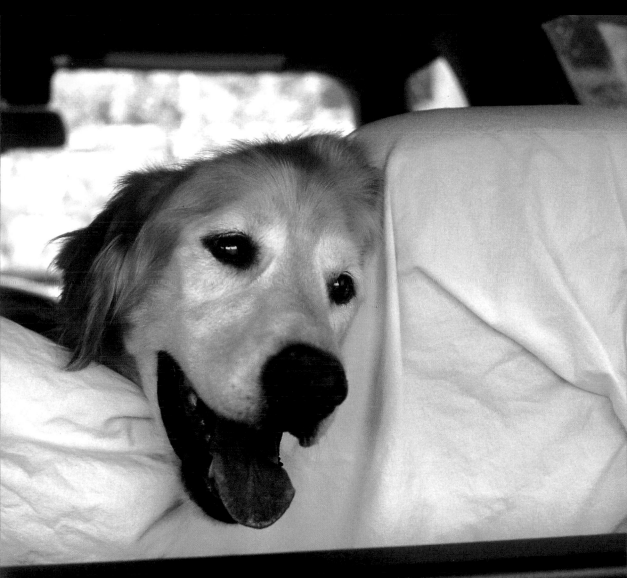

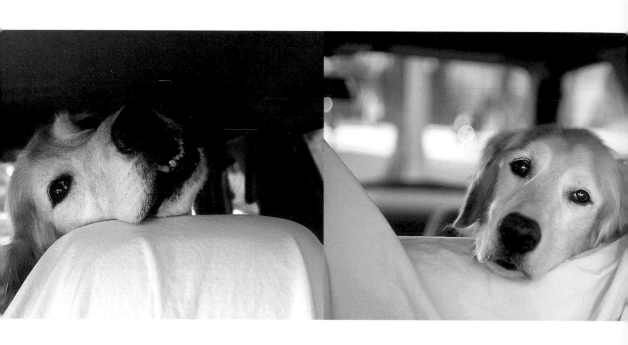

The first 3 nights in his new home, Rufus insisted on sleeping with me on my bed, no matter how many times I tried to get him to sleep in his own spot. I grew to love Rufus during those first few nights as I watched him sleeping. And on the fourth night, I looked at him and said, "Rufus, don't worry. I'm going to take care of you forever—I won't ever leave you." The next night and from then on, Rufus slept in his own bed. Maybe he realized he was really, finally home.

Escape Artist

Rufus was a free spirit. I found this out the hard way, when I left him home alone for the first time. He was actually waiting for me outside the house when I returned, which shocked me since I had locked up before leaving. That's when I saw it—a nice large hole in my front door, chewed through cleanly.

"Rufuuus!" I yelled, and saw him already scampering into the house and into his room. Of course, he did save me the trouble of cutting the hole myself for my newly installed doggie door.

Escape attempt.

I realized that Rufus couldn't be left home alone, so from that day on, he was with me wherever I went. But that never stopped him from escaping. Once at the studio, I turned my head for five minutes and he simply disappeared. We searched frantically for two hours and I thought for sure I had lost him, but I later got a call from the dog care center, which had been contacted thanks to his dog tag. He had wandered into a neighbor's office and was sitting there all along.

Rufus escaped many more times after that; I couldn't cure him of the habit for nearly 18 months.

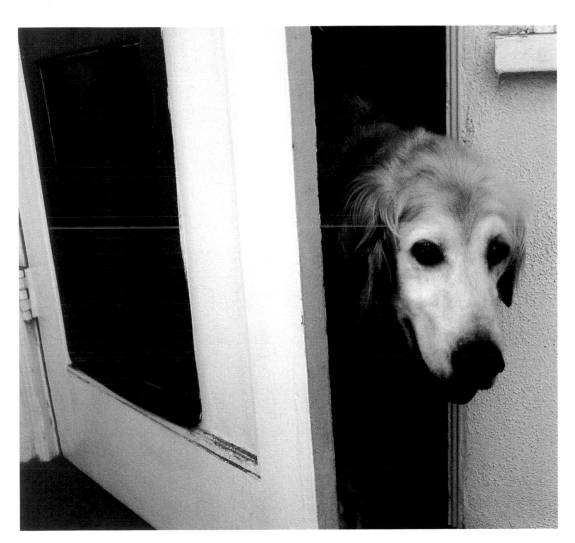

He never did use that doggie door.

Dog Photographer

Being a professional photographer, I naturally started taking pictures of Rufus wherever we went. Just for fun, I hung my camera around his neck and put on some funny sunglasses to see how Rufus would react. To my surprise, it didn't bother him at all and I was able to get a nice shot of him as he stood perfectly still for me.

While in Japan I showed this photo to my mentor, who immediately told me, "Reiji, this is it! Get your dog to take the photos!" I looked at him as if he had been staring into too many strobes.

But that was how it all started. The harness is custom made and the camera is lightweight. I took Rufus everywhere, and with a cable shutter release in hand, took shots whenever Rufus saw something interesting. He had a unique dog's eye view. This collection is what Rufus saw through the lens. This is his body of work. I hope you enjoy it.

Equipment List
Camera: CANON Level 2000
Lens: 28mm
Film: FUJI Provia

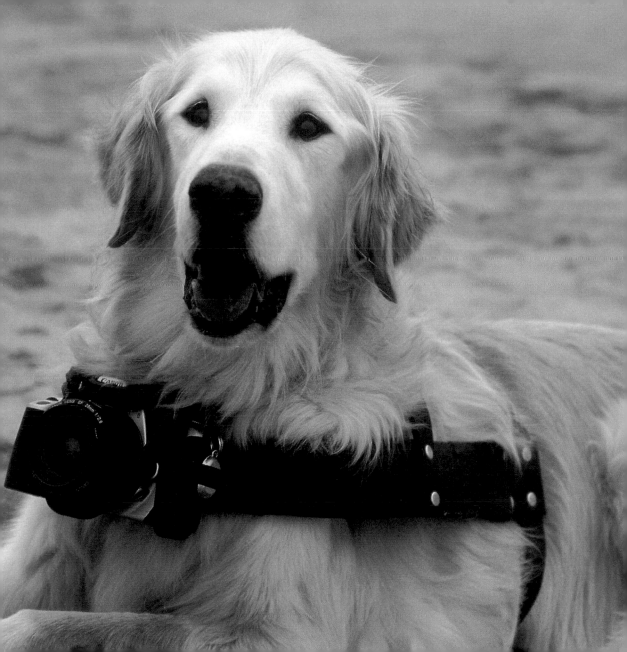

Dog Show. Rufus and I enjoyed going to dog shows. They're great events for people and dogs who like being with other people and dogs. There are always so many breeds and types; all being primped and groomed to look their best. But I always thought Rufus was the handsomest dog there.

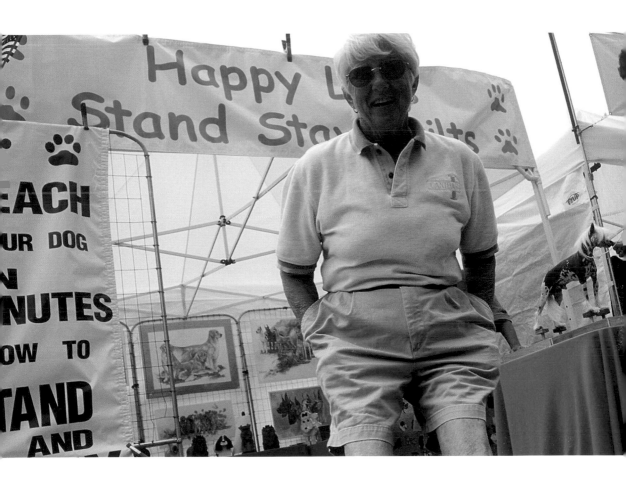

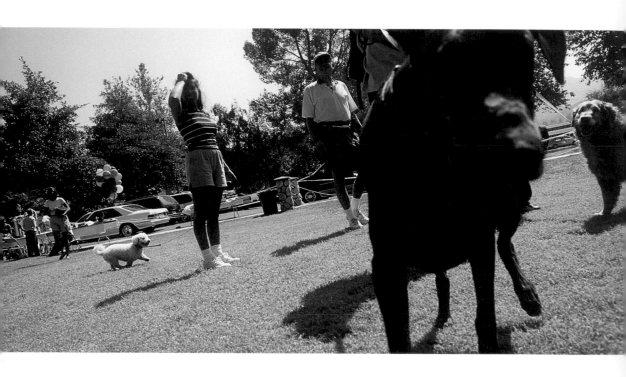

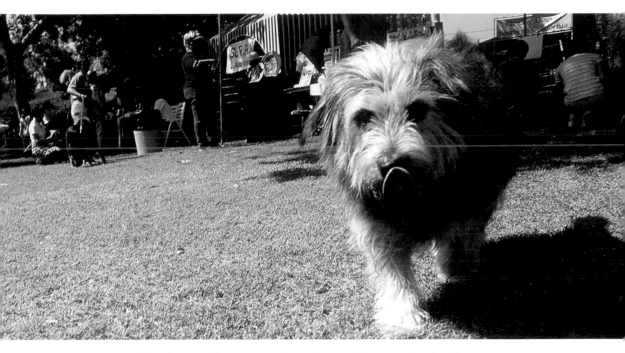

She kept going on and on about this new dog food...

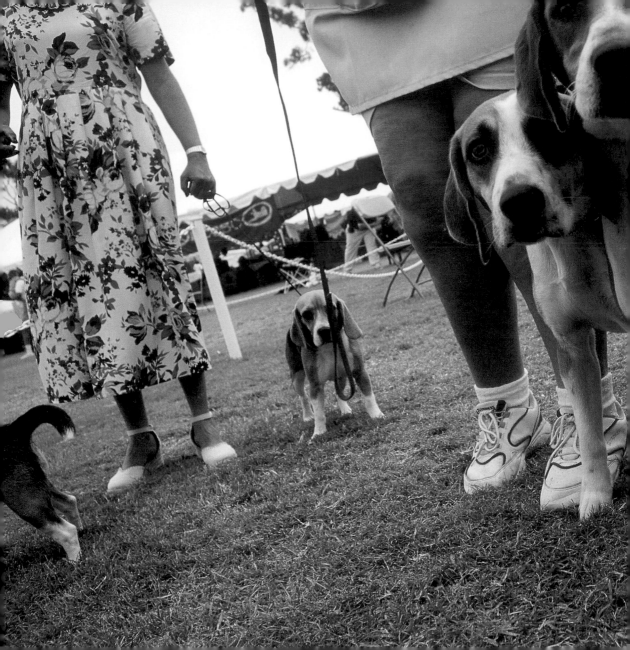

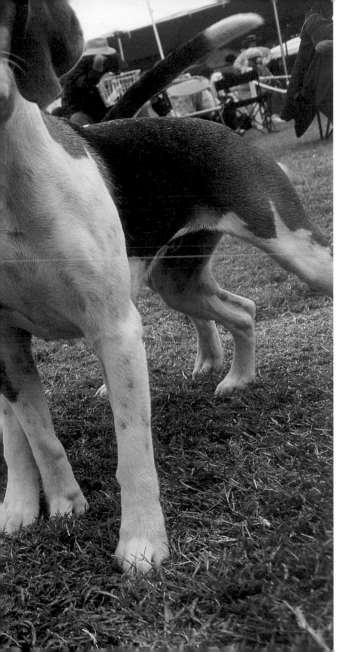

These boys looked
nervous, so I told
them to chill out.

Yes, I'm here to cover the show, thank you.

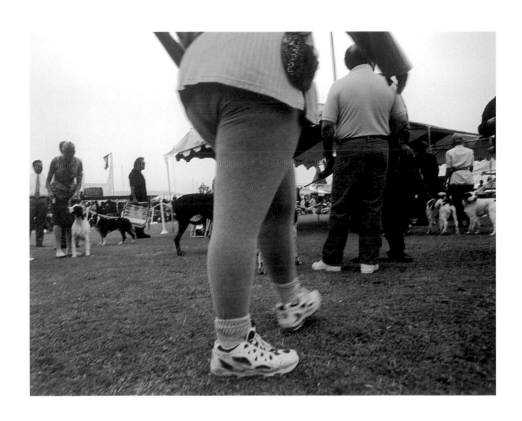

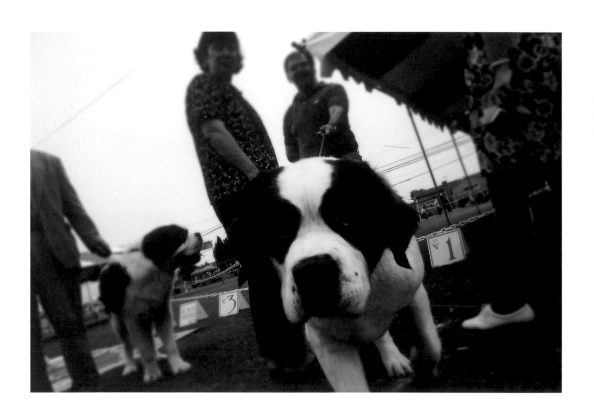

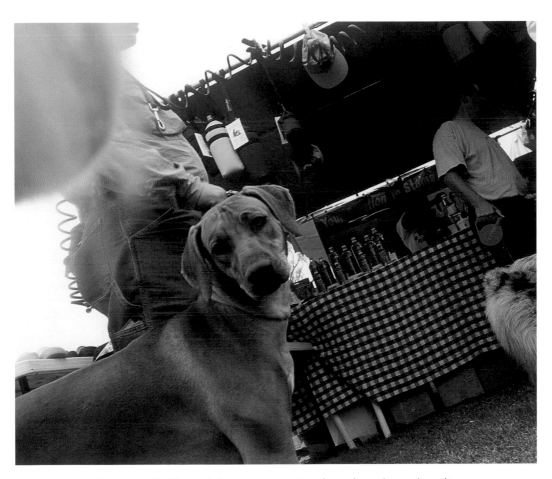

I agree. Selling stain remover at a dog show is an insult.

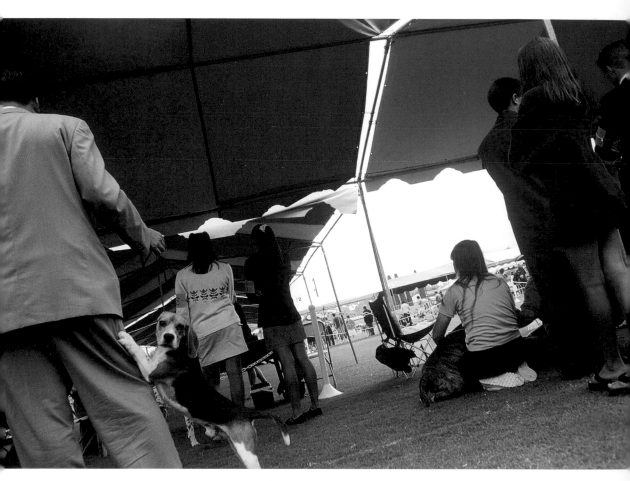

Boss! Boss! There's a dog with a camera around its neck!

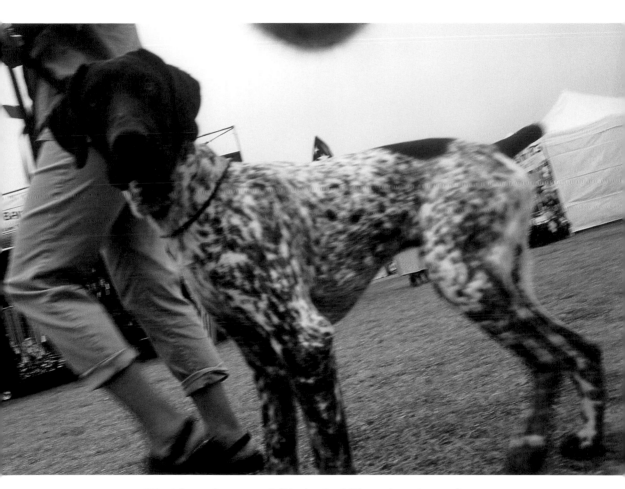

What breed are you? [He looked like 2-in-1 to me.]

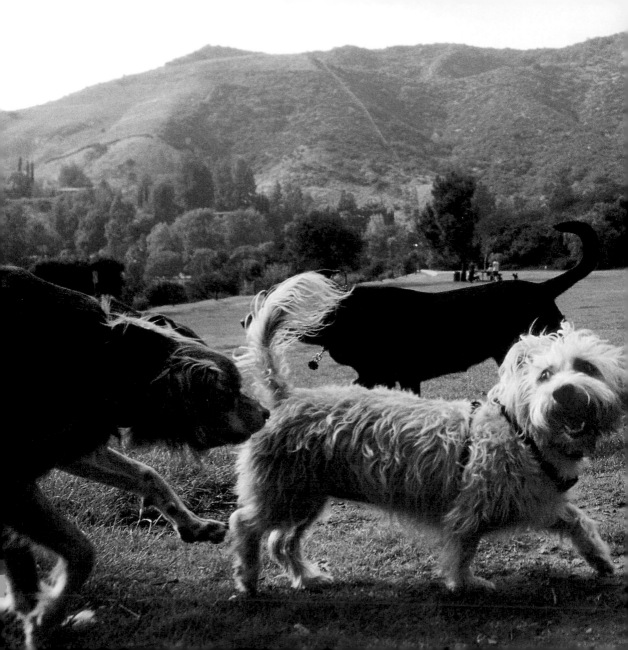

Dog Park. Dog parks are great because dogs get to do the things that dogs like to do, like run around and play. Rufus would greet the others as soon as we arrived, but then he would just sit in the shade and watch them play. He was a very friendly dog, but he seemed content to just watch. Maybe he thought he was human.

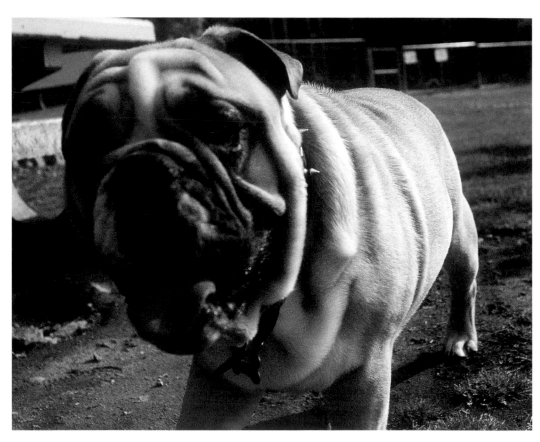

Wow! How fast were you running?

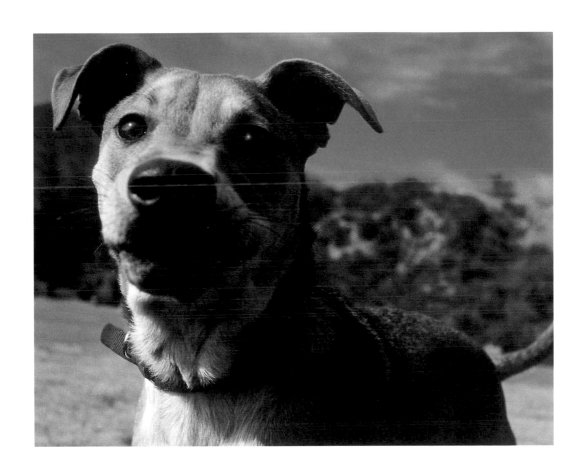

Whoops!

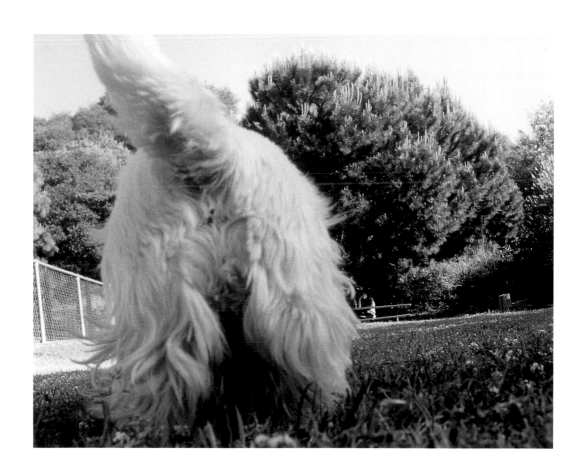

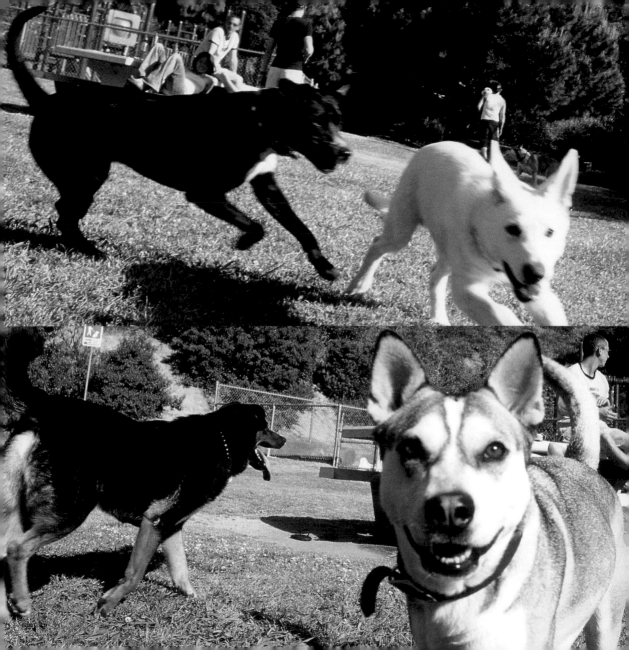

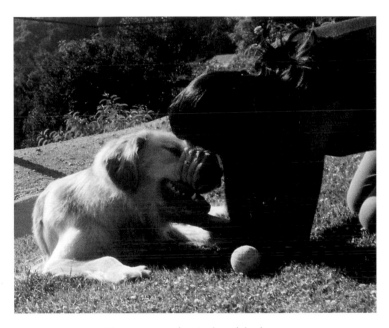

Hmm…maybe I shoulda been
adopted by a girl. [Just kidding!]

Dog Café.

A restaurant for dogs; what a nice idea! Rufus was so hungry when we went that he ate all of his lunch at once. It seemed as though he wanted more and was eyeing my lunch, too. I guess I should have ordered a doggie dessert.

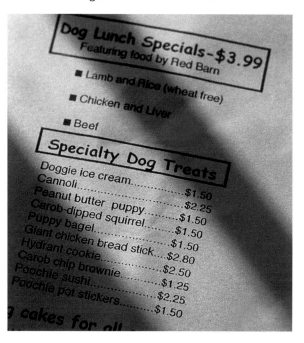

Mmmm..."carob-dipped squirrel"...delicious!

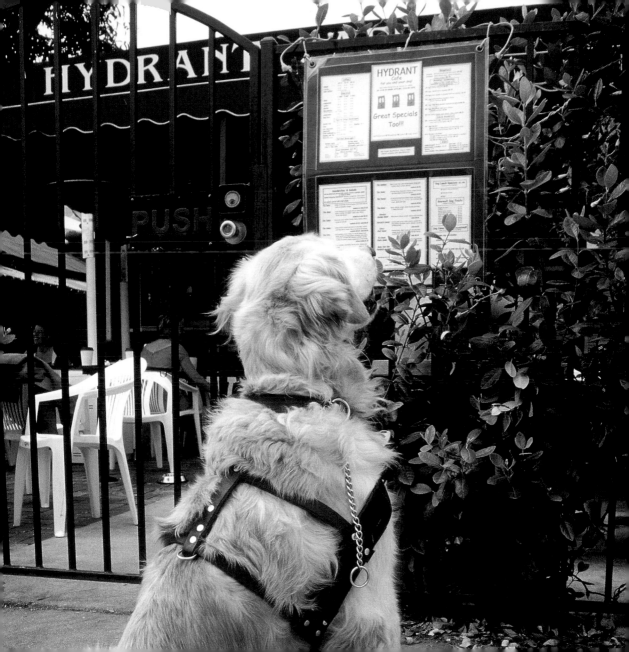

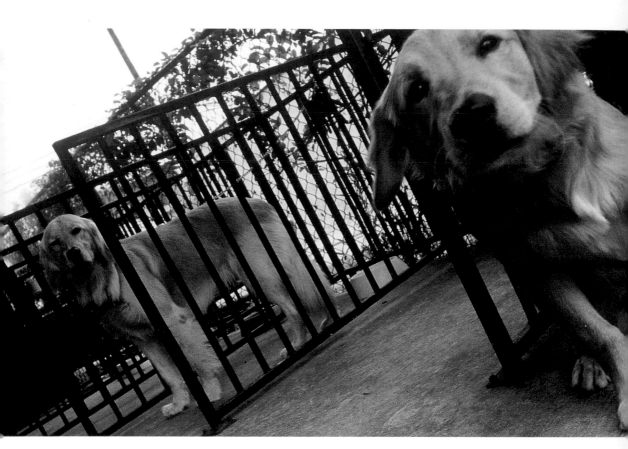

So how long you boys been waiting?

Ah, Mr. Rufus, let me show you to your table.

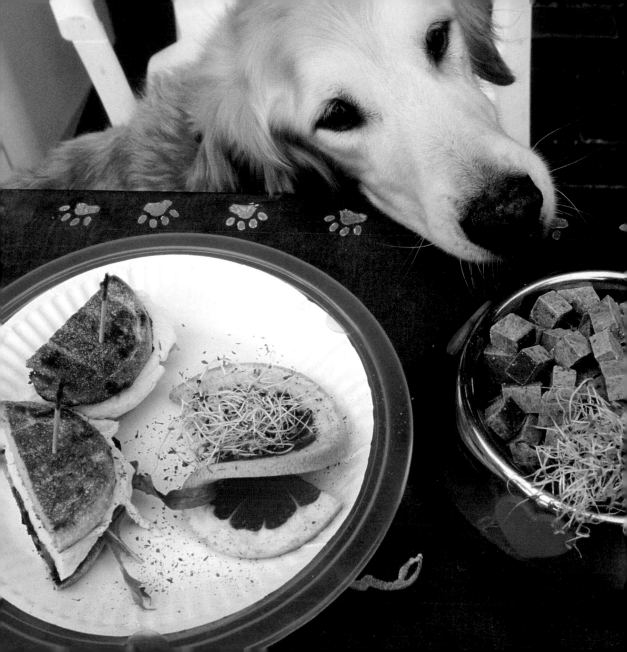

Lunch is served!
[Left: for my dad. Right: for me.]

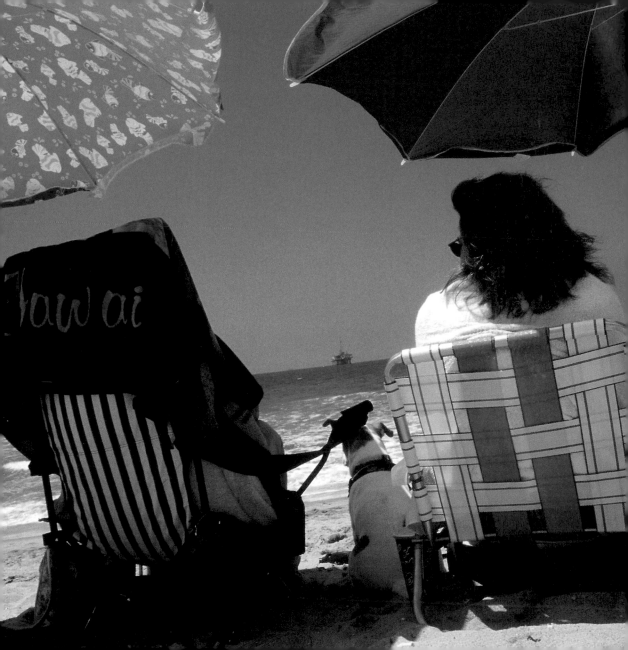

Dog Beach. Rufus loved the ocean. He never stepped into the water to go for a swim like some of the other dogs, but he liked to simply sit on the sand and look

out at the surf. I could see his nose twitch as he sniffed the ocean breeze. I took him to the beach during his last days.

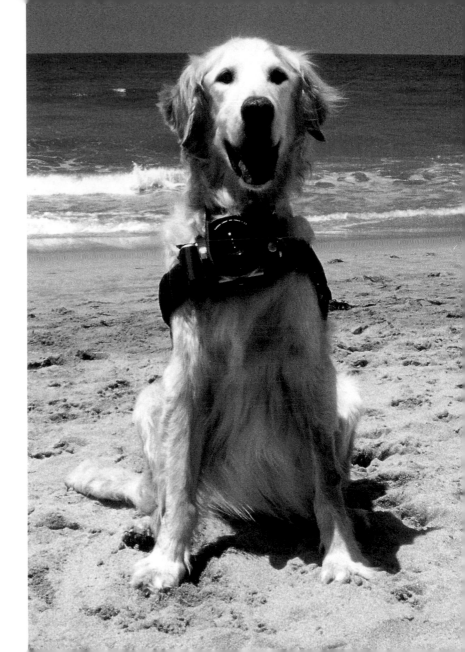

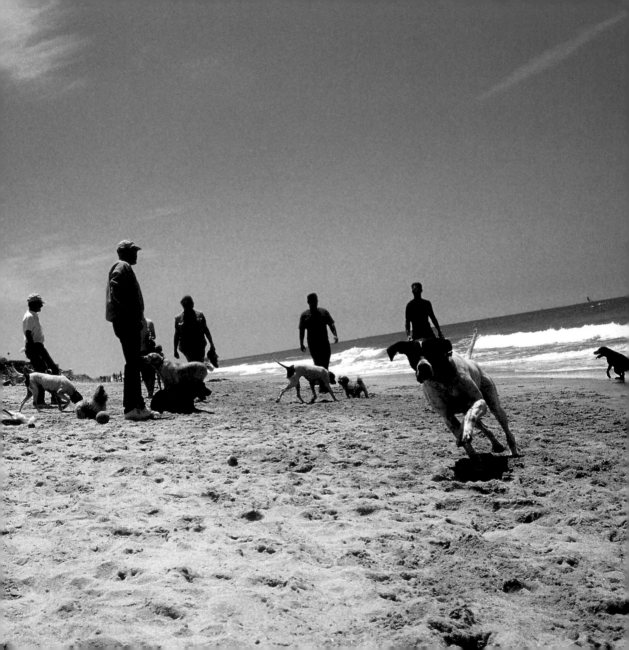

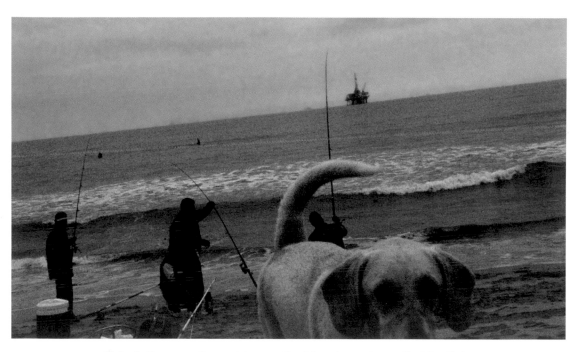

This fellow confessed to me that he doesn't really like fish.

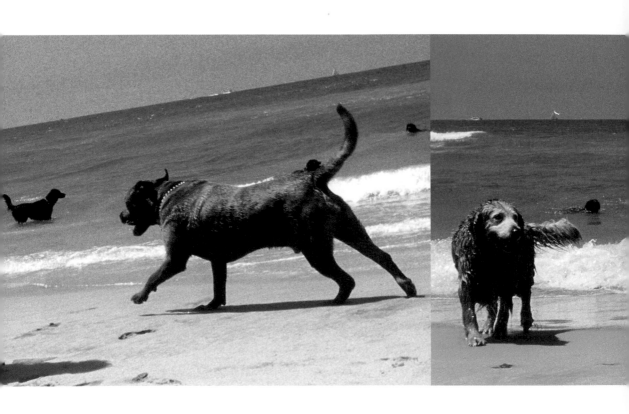

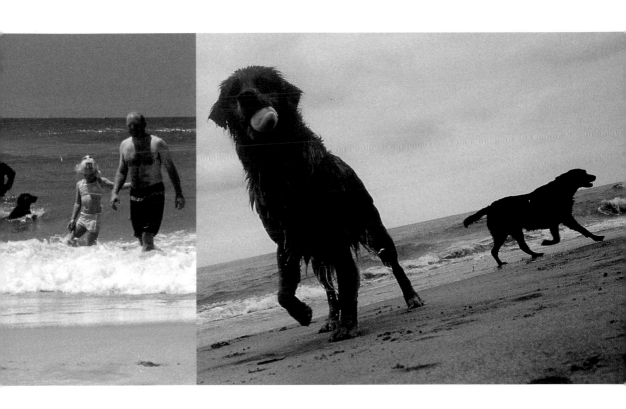

Around Town.

Rufus was a ladies' dog. Whenever we went for walks, he would always greet the girls passing by, and they would make a fuss over him. "What's your name? How old are you?," they would ask, and Rufus would always let them pet him or hug him. I think he knew he was a good looking dog.

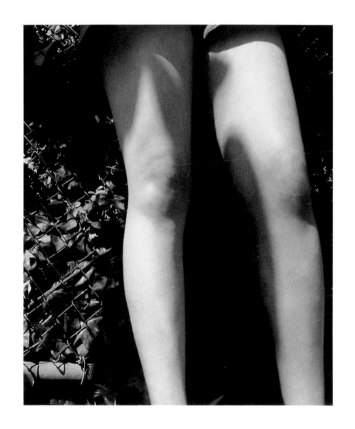

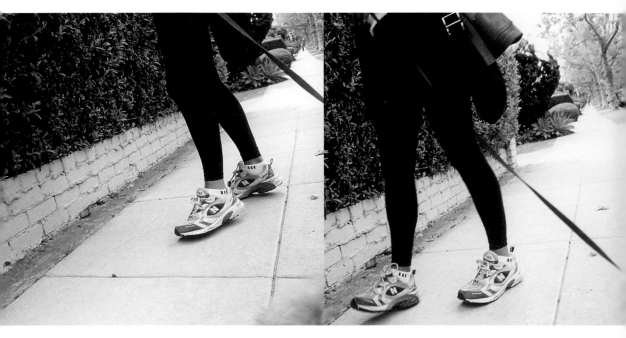

Here she comes... *...don't be nervous...*

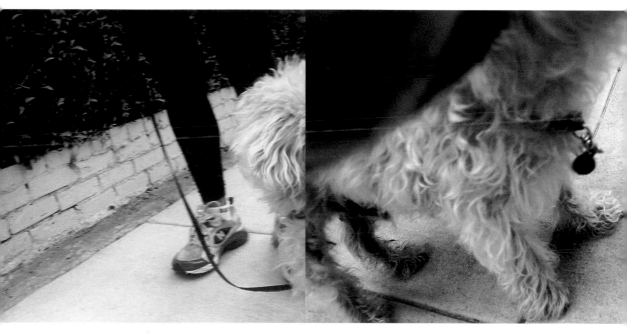

...just be yourself...

Your fur looks lovely today!

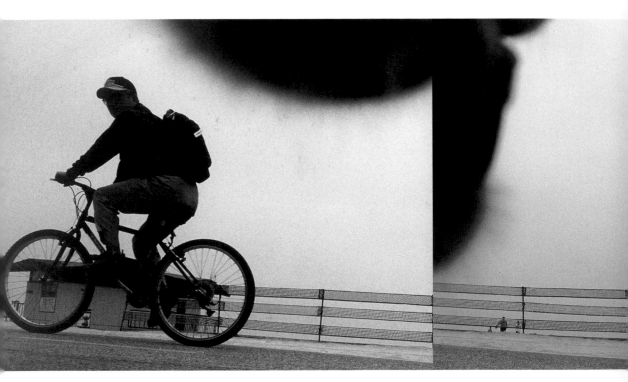

S'matter? Never seen a dog photographer before?

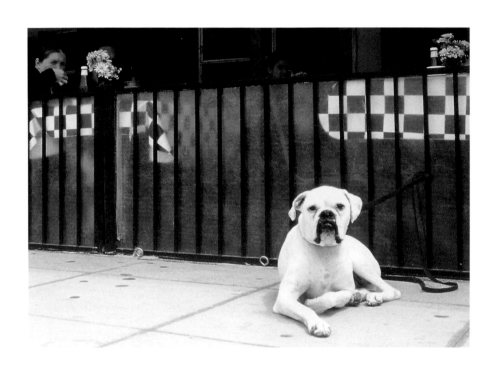

49

Lemme see! Lemme see!

When you're as close to the ground as I am...

…you never know what treasures you'll find!

I call this "Self-Portrait with Tongue."

Gotcha first!

Stairway to...

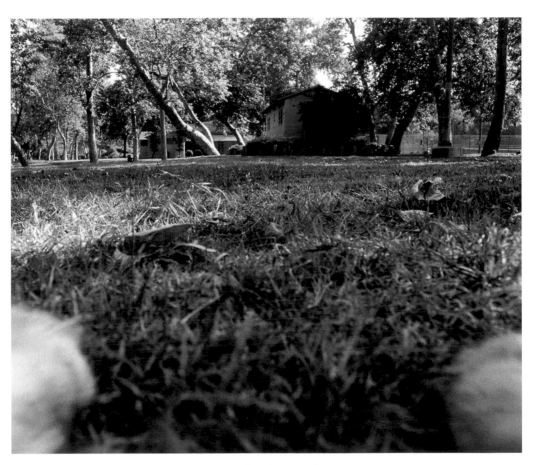

...dog heaven!

Friends

I don't remember whose bright idea this was [it could've been mine], but as you can see, the results were mixed. Vickie [Toy Poodle], Happie [Siberian Huskie] and Ron [Great Pyrenees] were some of Rufus' best friends. After this session, I realized that I had gone through a whole box of dog biscuits.

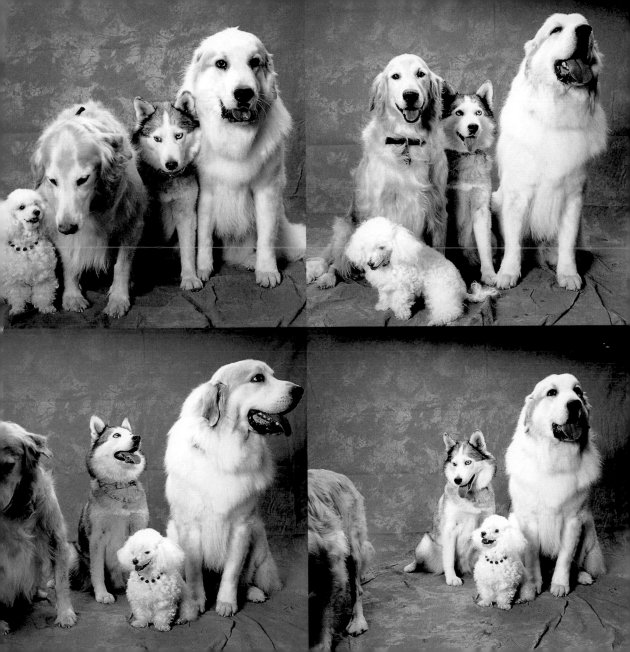

Goodbye, Rufus

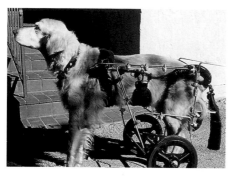

Rufus retired from photography in May of 2002. His age was starting to catch up with him and he was having a difficult time walking. He had developed arthritis and couldn't see very well. In December of that year, the veterinarian suggested that Rufus be put to sleep. I couldn't do it.

I nursed him every day as best as I could, but in the end Rufus stopped eating; even his favorite bread. On January 2nd, 2003, Rufus passed away in my arms as I was massaging him.

I used to wonder whether Rufus was happy living with me, so it made me feel better when a friend of mine thought Rufus had a fulfilling retirement. "He's in your heart now", said my friend. "No," I told her, "he's in a much deeper place. He's in my soul."

Rufus always loved being with people. He was big and gentle; he never bit anyone. Even when a smaller dog bit him on the ear once, Rufus didn't get angry. The one thing that he taught me was kindness; he made me realize there are so many abandoned pets like him, living in kennels waiting for their guardians to come back.

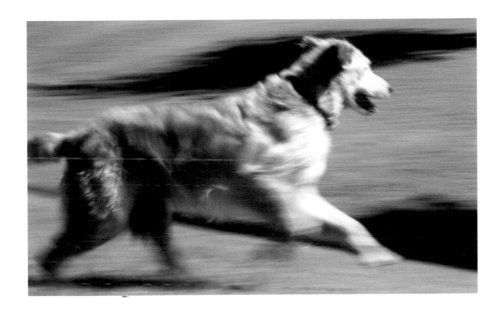

Some of these pets find new people to care for them, but most don't. I hope to continue adopting these animals, and try to find others who can as well. I feel that my time with Rufus was special, and so rewarding that I can't wait to experience that feeling again.

Thank you, Rufus, I'll never forget you.

—Reiji Kanemoto